Maolong Brush:

A Unique Instrument for Calligraphy

Elegant Guangdong Series Editorial Board

A New Writing Brush
Humble Origin of Maolong Brush

Transcending Worldliness
The Art of Maolong Brush Calligraphy

Passing on of the Craft
Inheritance of Maolong Brush Making

可以保其身而無先王正教以勉天下仁本不立時模之知誰弓程明此道兮兄弟
於時逝其所為高不逮漢唐之間作記三代以前師傅一尊帝王莫盛獻獻院生而
享之君臣何如此南渡之後據據其世非拔拔充反臣之主雖可其立仕之兩專郡以
以以間之大患羽可易挽大蒙漢而布素量敝玩雙雷國討曰非世往坐夫矣矣
不以成疾渡之功王於善惡不以用檜佞置刑賞失當怨憤生禍和漆子兵之益
帝中為而氣愈固如久歷之之氣息奮小及廣宗之世馬亦渡階為之搔素於玩二次
視之公矣孔子曰人之生世也律可免刑又諸廣之之詩曰王洞一案國風於二次
方平君境侵生理在直宜畑玩者龜墓亦立人之心時斷言如別姜惡於二二
芳代其天下國家治亂待驗狄宋言據選並元嚴草創于邑亡崖山近巳
於此記五初國陸浹相張太傅私治事友冬方戶都待卿前廬東右市一
廟以記五初大廈川都正邑與十泛母崔弓節葉之方御史近巳
劉公大廈川都正邑與十泛母崔弓節葉之方御史
思仁詩其不來公所之丁賣其決曰刑世考公記之末半公去為方御史
容其其府通料劉君州龍巳寅冬刊成是役也一朝而集利命不曲於
以大采慨尚來堪華硯以有婢府卿先生之命念並元
松治記末聞於天力夫書之恍其不羈工也南游廓夫陳弈章錢
君名脫葉父來父名者屬東山先生耳靖西庭先生為作寸記許之話魚待之年弘治巳壬夏府引駑馬君行
問其破敦息夂之石先村共碑於廟中梁西涯文宇巳耳劉西碑起二金揮玉映先熙宇宙堂二元得之无先金得

Foreword

Just as quills were once the principal writing instruments from the 6th century until the mid-19th century in the history of Western writing, the Chinese brush, or ink brush, is an important writing tool for Chinese calligraphy to develop into a world-renowned art medium and remain prominent to date. Traditional Chinese writing brushes have been mostly made from the hair of some animals, such as the weasel's or goat's hair. However, in the two-thousand-year long history of Chinese calligraphy, due to some accidental factors and chance, literati and refined scholars or skilled craftsmen would like to use some special natural materials other than animal hair to make "brush", aiming to achieve unique artistic effects. Among them, Maolong brush is one of the most famous.

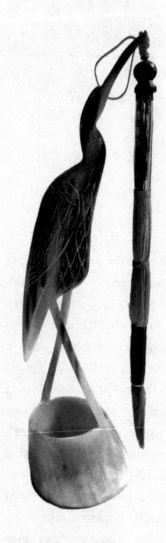

Maolong brush hanging on
a crane-like pen rack

The inventor of the brush is said to be Chen Xianzhang (or Chen Baisha, 1428–1500), one of China's well-known Cantonese Confucian scholars, poets, and calligraphers, during the Ming Dynasty (1368–1644). During the reign of Emperor Chenghua (1465–1487), Chen Xianzhang built a cottage to educate his disciples and spread his ideas on the Guifeng Mountain in Xinhui, Guangdong. Legend had it that, a friend visited him one day and asked Chen for a piece of calligraphic work. It happened that, he did not have any handy brushes available, and then he hit upon an idea. He plucked some cogongrass which abounded in the mountains, and "bound such into a brush". Chen dipped it in ink and penned the work with a flourish of the brush. The strokes were bold and rigorous, the unfilled space vivid and lively. Overjoyed, Chen named it the Maolong brush. As Chen was styled by the contemporary as "Master Chen Baisha", the Maolong brush is also called "Baisha Maolong brush".

Actually, making Maolong brush is pretty sophisticated, far from the simplicity as told in folklores. However, there were two key points in the folklore, one is that it was invented by Chen Xianzhang, the other is that the brush is made of cogongrass, which preferably grows on the Guifeng Mountain in Xinhui.

As hundreds of years have elapsed, the technique of making Maolong brush, which originated in the Ming Dynasty and flourished in the Qing Dynasty and the Republic of China, had been lost after the outbreak of the War of Resistance against Japanese Aggression in the 1930s. The Maolong brush that is now made is the result of step-by-step reverse engineering by dismantling whatever could be collected of the brush from private collectors and analyzing the characteristics of the calligraphic works by Chen Xianzhang. In 2008, the Baisha Maolong brush was placed in the catalog of the second batch of national intangible cultural heritage due to the unique and singular craftsmanship in its making and as a representative brand of Lingnan culture. It has since got better protection and undergone better development.

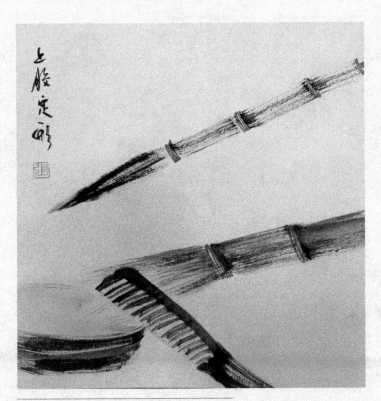

A traditional Chinese painting of MaoLong brush

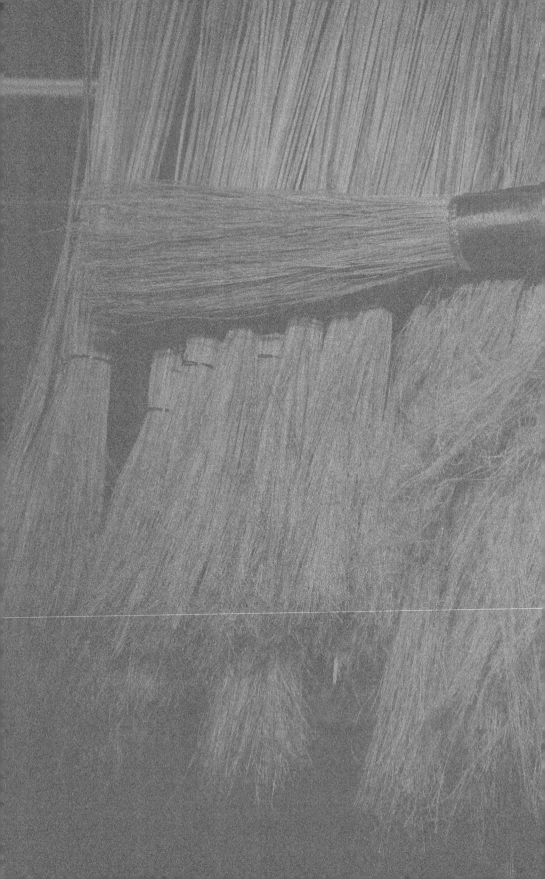

A New Writing Brush

Humble Origin of Maolong Brush

The Inventor
Baisha, a Towering Intellectual and Founder of
Philosophy of the Mind

The Making
Made with Locally Grown Grass,
Stringent Steps and Virtues

The Brush
Maolong Brush Calligraphy Rocked
the Literary Circle

The Inventor

Baisha, a Towering Intellectual and Founder of Philosophy of the Mind

Chen Xianzhang (1428–1500), byname Gongfu, self-styled Shizhai, known as Master Baisha by his contemporaries, was born in Xinhui, Guangdong. Chen attained fame while he was young. He passed the provincial civil service examination and was admitted to the Imperial College at the age of 19, but failed twice in the highest imperial examination. Later, he went back to his hometown to take Wu Yubi, a master neo-Confucianist, as his teacher for 10 years. When he turned 38 years old, at the invitation of the grand secretary of the Imperial Academy Qian Pu, he went to the imperial capital again and participated in the highest imperial examination, however he failed a third time. He finally settled in his hometown and gave lectures, and founded the "Jiangmen School", advocating free, open intellectual atmosphere of "valuing the inquisitive spirit in learning" and "independent thinking".

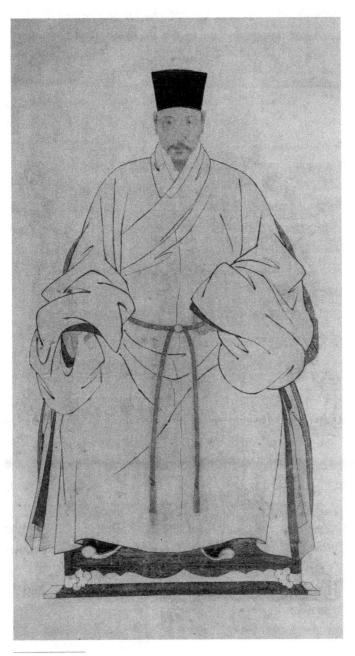

Chen Xianzhang

Chen Xianzhang's biggest contribution comes from his shaking off the doctrines of the neo-Confucianism represented by Cheng Brothers (Cheng Hao and Cheng Yi) and Zhu Xi. The Jiangmen School formed a connecting link with later Yaojiang School founded by Wang Yangming, and the two jointly brought the philosophy of the mind to its peak. Unlike Zen's practicing meditation as a means to gaining enlightenment, the philosophy of "sit still, clear the mind, enlighten yourself" he upheld stresses forging an independent speculative spirit after extensive reading. On the backdrop that books handed down from past generations amount to staggering quantity, one cannot rely on mechanical reading and rote learning, or parroting others' ideas. Instead, one should calm the mind to comprehend and speculate, form one's own understanding, and put forward questions without hesitation when coming across any difficulty. "Slight doubt brings forth small progress, serious doubt, big progress. Doubt is the key to enlightenment." Only in this way can one attain true knowledge. He was dissatisfied with the academic barriers created by the canons of the Cheng Brothers and Zhu Xi which were upheld by his contemporaries. He proposed to "follow the law of nature", that is, to break away from the doctrines and conventions, to free the ossified mind; one should learn rigorously with a lively spirit, seek knowledge without following slavishly established norms, pursue a realm of the mind and set it free as the wide sea allows the fish to leap about and vast sky the birds to fly. Huang Zongxi, a well-known scholar at the closing period of the Ming Dynasty and the beginning of the Qing Dynasty, a forerunner of enlightenment thinkers in China, lavished praise on the achievements of Chen Xianzhang, "the scholarship of the Ming Dynasty takes a turn for the subtlety and essence in the hands of Baisha."

Chen Xianzhang was an outstanding educator, had thousands of followers from across the country under his tutorship. He treated all disciples equally regardless of their wealth. He did not only impart knowledge but paid more attention to the cultivation of the character of his disciples. His disciples included Liang Chu who served as the grand secretary of the secretariat, and Zhan Ruoshui who was a great Confucian scholar and later headed three ministries, namely, the ministries of Rites, Official Personnel Affairs and War. After Chen's death, the imperial government decreed that a memorial place be built, named Baisha Clan Memorial Hall. In the Wanli period (1573–1620), the emperor further decreed that Chen be enshrined and admitted to the Confucian temple to receive accompanying sacrifice. He was posthumously awarded the title Wen Gong. He was the only scholar from Guangdong admitted to the Confucian temple receiving accompanying sacrifice.

Selected Works of Chen Baisha

The Making

Made with Locally Grown Grass, Stringent Steps and Virtues

Regarding the invention of Maolong brush by Chen Xianzhang, his disciple Zhang Xu recorded in "A Biographical Sketch of Master Chen Baisha—A Historiographer of the Imperial Academy", "while living in the mountain, as occasionally there was a shortage of brush supply, the master was forced to bind cogongrass in place of brush." The mountain wherein Chen Xianzhang lived is the Guifeng Mountain in Xinhui, the cogongrass which abounds in the place is particularly pliable and extremely resilient. The Chapter "Plants" of *The Local Annals of Xinhui* has the following record, "cogongrass grows in pits of mountains, Chen Xianzhang of the Ming Dynasty had plucked it to make it into brush, and this practice is still followed to date."

Guifeng Mountain, the birthplace of Maolong brush

The processing of the raw material consists of several steps, including selecting grass, soaking, hammering, removing green peel and scraping grass. The scraped grass has to be gummed and combed, and then the grass straws are bound with silk thread into a handle, and a Maolong brush is made by now. In order to make a brush with the four benchmarks, "sharp, round, even, stiff", the brush so made is then subjected to "tipping", that is, dipping the brush into water and adjusting the brush tip by stretching it.

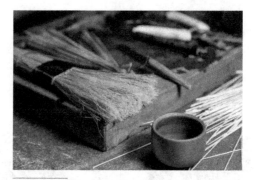

Select grass

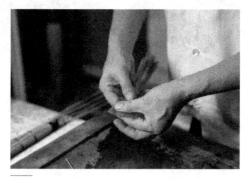

Soak

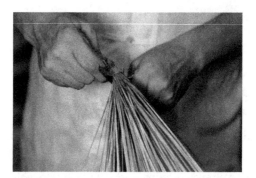

Coil and fasten

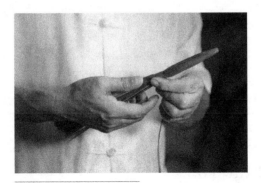

Bundle the processed grass

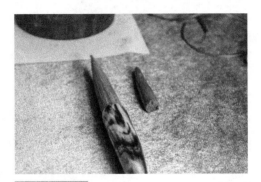

A finished brush

Each Maolong brush is unique in its making. For instance, in the entire making process, the cogongrass chosen must be neither too overgrown nor too tender, control of the duration for soaking grass, hammering flat the grass roots, quick scraping according to the requirements for brush shape and writing effect. Each process requires the brush-making craftsman to make appropriate adjustment as his experience dictates, while such technique and skill can only come from instruction and personal experience received as well as individual exploration by the craftsman.

The Brush

Maolong Brush Calligraphy Rocked the Literary Circle

Historical records have entries that the neo-Confucianist Zhu Xi (1130–1200) of the Southern Song Dynasty had bound grass into writing brush and written big characters therewith which has been handed down to our time. However, making grass into writing brush, developing such into a unique writing style, and even founding a school actually originated from Chen Xianzhang. Dissatisfied with the "Secretariat Style" which featured woodenness, primness, upright and roundness prevalent among scholars since the establishment of the Ming Dynasty, Chen sought to innovate calligraphy writing, pursuing an extraordinary style which was "conforming to principles while breaking out of the box, unrestrained without going to unscrupulous, appearing clumsy but all the more artful, and being rigid without losing pliability". This prompted him to find a new writing instrument to realize his ideal of calligraphic creation.

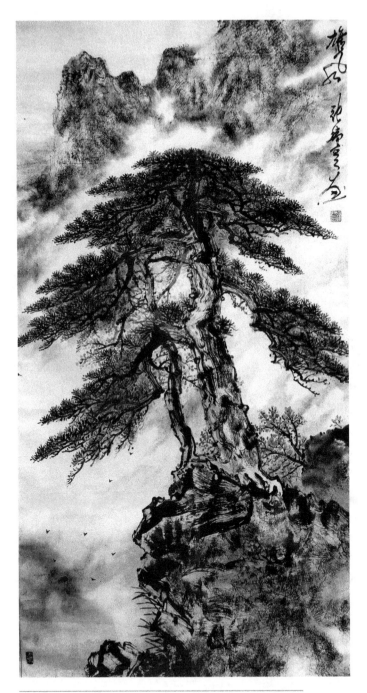

Great Pine Trees drawn by Zhang Ruiheng using Maolong brush

Maolong brush made of cocongrass fiber is thicker and stiffer than brush made of animal hair, inferior in ink absorption capacity. However, its writing style is hoary, rugged yet rigorous, magnificent and majestic, generating an artistic effect of "appearing clumsy but all the more artful", which cleared the plump and graceful style of the Ming Dynasty calligraphy and brought the viewer a powerful visual impact.

The then mainstream circle of calligraphy was under the heavy influence of Zhu Xi and the neo-Confucianism thereof; the prevailing writing style was exactly like that of the neo-Confucianist like the Cheng Brothers and Zhu Xi, strict adherence to the established writing regime without a gleam of spontaneity in each and every stroke penned. The Maolong brush calligraphy by Chen Xianzhang featured clumsiness without expelling ingenuity, rigid with softness, vivid and lively, and manifested the personality of the calligraphy. It was indeed of epoch-making significance, refreshing the mind of the contemporary people. Later generations sang the praise of him with the statement "Baisha Rocked the Country".

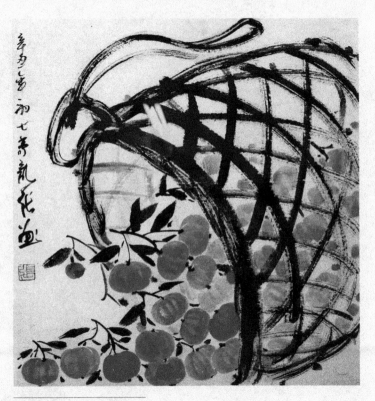

Tangerines by Zhang Ruiheng

老夫天荒之

雨淋雪

折香三

滄舟破

如年凡兀

家老兄

短架他

本苦熱

來指節

夜吟何味

銘凉境

汪洋

一醉京市

搜句些

利稚袂

康地傳覓

山家嘴

一遠遠

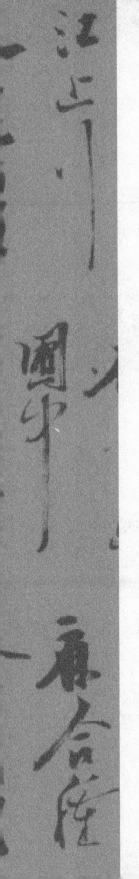

Transcending Worldliness

The Art of
Maolong Brush Calligraphy

Writing Style
Rugged Branches Styled
a New Calligraphy School

Poem of Laud
Maolong Brush Consecrating Handwork

Treasured Calligraphy
The Most Revered Stele of Lingnan

Writing Style

Rugged Branches Styled a New Calligraphy School

Chen Xianzhang pursued a style of "seeking immobility from mobility", so the Maolong brush calligraphy of his featured wild and unrestrained flourish, and the flow of strokes was permeated with great momentum. Qu Dajun (1630–1696), a patriotic poet and scholar in late Ming Dynasty, commended his Maolong brush calligraphy as, "noble spirit rising high into the air, as though stiff branches shooting forth, unique in his own style." The modern calligrapher Mai Huasan in *Essays on Calligraphy of Lingnan Area* commented on Chen Xianzhang's Maolong brush calligraphy as "that the startled snake shooting into water", and "thirsty steed galloping to a fountain", which delineated the extremely dynamic aspect of Chen's calligraphy.

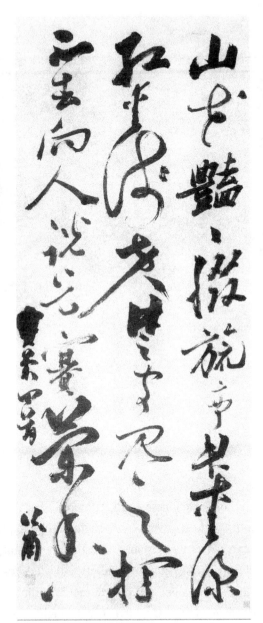

Calligraphic work of Chen Xianzhang, possibly using
Maolong brush

23

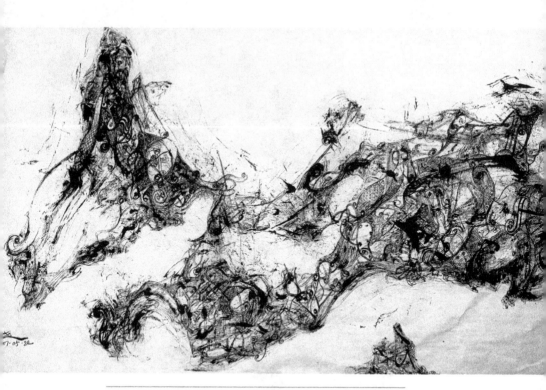

Hollow strokes and silk–thread artistic effects created by the brush

In the pursuit of contentment and life interest, Chen's theory of calligraphy fully blended with his thought on philosophy of the mind, which shatters the obstacles of established traditions and shakes off restrictions set up by the myriad predecessors. He attained in his calligraphic art the real mental realm of holding the entire universe in the self, perusing the eight extremities of the universe with the mind, acting spontaneously on the spur of the moment.

Qu Dajun described the Maolong calligraphy of Chen Xianzhang as "majestic and dignified, is it not that it transcends the realm of the sainthood, while the hand and the brush both seem lost to him!" "majestic and dignified" refers to an aesthetic state of both stateliness and ecstasy, which means Chen's Maolong calligraphy attained a state of "transcending the sainthood" where both the hand and the brush appear nonexistent, as though the calligraphy comes into being naturally; it requires the appreciator to apply his mind to appreciate the beauty of it.

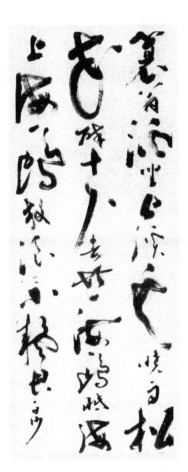

Calligraphic work of Chen Xianzhang

25

Poem of Laud

Maolong Brush
Consecrating Handwork

Portrait of Chen Xianzhang

Chen Xianzhang took great pride in the Maolong brush and Maolong calligraphy he invented. He likened the Maolong brush to "gentleman Maolong", and composed a poem to laud its virtue. For instance, he sang praise of the wonder-working property of Maolong brush with the statement of "slight effort by gentleman Maolong consummates the work of hand". Words like "The python and dragon in the hand could not be rendered docile" and that "I'd bind cocongrass into ten-meter sweep and clean the Luofu mountain" described the characteristics of Maolong calligraphy invented thereby in romantic depiction, and highlighted his love

Calligraphic work of Chen Xianzhang

for Maolong brush. In the poem titled "Gifting Maolong Brush", he described gifting his friend with handmade Maolong brush and the majestic bearing of Maolong, "Gifting you with grass-root a thousand-meter long, in leisure time you may edify the mind by writing calligraphies a thousand strong." He laid special stress on the unique "tone" and extraordinary majesty of Maolong calligraphy.

Chen Xianzhang's Maolong calligraphy set the writing trend of the time, and his contemporaries took pride in having a piece of his Maolong calligraphy. Many of his disciples including Zhan Ruoshui, Wang Jiankui and Zhao Shanming studied Maolong calligraphy under his guidance and took over the mantle. Later generations heaved praises on Maolong calligraphy. Wang Fuzhi (1619–1692), an eminent philosopher and historian in Late Ming Dynasty, acclaimed the naturalness and unrestrained easy-going of the flourishing Maolong calligraphy in his poem "After Reading Poems by Messrs. Chen and Luo":

Baisha wields a Maolong brush, a gourd buries in fly trails.
Say not I am conceited and he presumptuous, together we
luxuriate under the blue sky in dusk.

In the early Qing Dynasty, Peng Sunyu also wrote "Ode to Chen Baisha's Cursive Calligraphy" singing the praise of Maolong calligraphy:

In his later years, he casually wrote large characters, varied
strokes bring exquisite appeal.
Why bother to follow slavishly Wang Xizhi, in hearty rendition
he again attains lofty ideal.

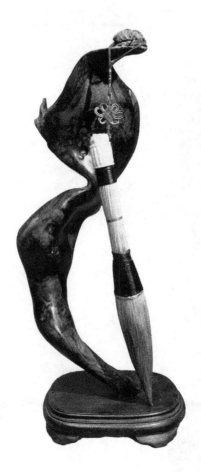

Maolong brush hanging on a pen rack

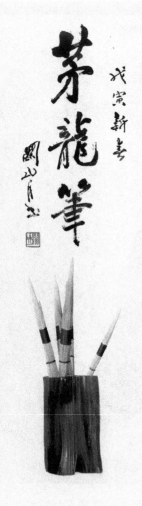

Maolong Brush, handwritten by Guan Shanyue (1912–2000), a master of the Lingnan school of painting

More than a hundred years later, a fellow poet Hu Fang brought Maolong brush back to life from neglect, imitated and learned from Chen Baisha's Maolong calligraphy. He wrote "An Ode to Master Baisha's Maolong Cursive Calligraphy" to express his understanding and admiration of Chen Xianzhang's Maolong brush calligraphy:

> *The mountain of the savage people used to grow giant rabbits, its fine hair mistaken for grass.*
> *With divine prowess it is captured, with skin removed and bone retained to be impregnated with clam shell ash.*
> *Bound with red vine it is rigid and straight, the stalk is made into the handle and the root the tip.*
> *The dragon transformed into the dragon-bamboo cane, in moving it brings forth roar of the wind and thunder.*

Chen Xianzhang's Maolong calligraphy is unique in its style, and these poems acclaiming Maolong calligraphy introduced infinite charm to it, making it a brilliant gem in the Lingnan culture.

Treasured Calligraphy
The Most Revered Stele of Lingnan

Stone inscriptions including Scroll of "Poem on Growing Castor Oil Plant", and "On Big Head Shrimp" (which means careless and heedless person in Cantonese) written with Maolong brush by Chen Xianzhang could all be justifiably listed among classics of Maolong calligraphy. The Maolong calligraphy work Ciyuan Temple Stele completed one year before Chen Xianzhang's death is reputed as "the No.1 stele of Lingnan" because of its unique artistic effect of calligraphy and profound historical significance. In 1958, Premier Zhou Enlai paid a special trip to admire the Ciyuan Temple Stele when inspecting the Yashan Historic Site in Xinhui District, Jiangmen City.

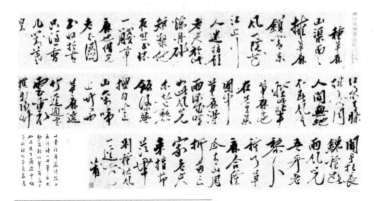

Scroll of "Poem on Growing Castor Oil Plant"

Chen's handwriting of
"On Big Head Shrimp"

The former site of the Ciyuan Temple where in the Ciyuan Temple Stele was seated was the temporary capital of Zhao Bing, the last emperor of the Southern Song Dynasty more than 700 years ago. More than 200 years after the fall of the Song Dynasty, Chen Xianzhang proposed to build the Ciyuan Temple in the site to commemorate the emperor's mother who sacrificed her life for the country at that time. The Ciyuan Temple Stele was erected in the temple, the content of which was written in Maolong brush by Chen Xianzhang himself. The Stele is 1.8 meters high and 1.05 meters wide. The 4 characters on the stele head, " 慈元廟碑 " are written in regular script, with a diameter of 9 centimeters each. The body text has more than 600 characters, and the postscript more than 100 characters, running script and cursive script alternately employed, with a diameter of 3–5 centimeters.

Chen Xianzhang's calligraphy style in his later years is vividly displayed in this stele. The whole work has a distinctive style of its own, which is rigorously laid out; the layout and content of the text highlight and complement each other. It expresses unadorned sentiment while conforming to the bounds of composition, forms an independent entity without affectation, and manifests the unique characteristics of Baisha Maolong calligraphy. At that time, his Maolong calligraphy had attained consummation, the inscriptions on the stele were vigorous, powerful, and charming with appropriate rigidity and plumpness, forming an integral entity. At a glance, the whole article appears crisscrossing and interlacing, with majestic momentum, properly spaced out and with appropriate intensity; at closer inspection, the strokes are vigorous and unrestrained, bold and precarious, with flowing elegance, simple and majestic.

The Ciyuan Temple Stele attains high artistic value in calligraphy and is also an important historical document. The stele accords with Chen Xianzhang's lifelong educational mission of enlightenment. By learning from the history to assess gains and losses, examining the reasons for the demise of the Southern Song Dynasty, he revealed his further attempt at rectifying the prevailing national mentality and folk custom.

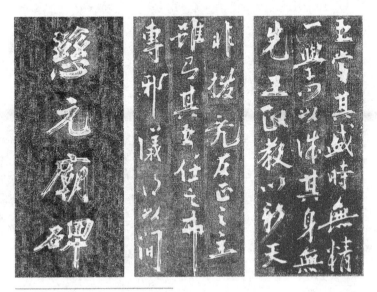

Inscriptions of Ciyuan Temple Stele

Passing on of the Craft

Inheritance of Maolong Brush Making

Development
Ups and Downs of the Brush-making Industry

Inheritor
Protecting Tradition and Innovating

Development

Ups and Downs of
the Brush-making Industry

In the late Qing Dynasty, Maolong brush slowly found its way into the upper class. During the Kangxi period (1661–1722), shops specializing in making and selling Maolong brushes were opened in Xinhui, which stayed in business uninterrupted until the end of the Qing Dynasty. Famous ones included "Jieyuan Zhai Brush Store", which later moved to Hong Kong and renamed "Jieyuan Brush Store".

After the founding of the Republic of China, the industry of Maolong brush gained some development, and there came into being many shops making Maolong brushes in Xinhui. Maolong brush business prospered, and "a brush-making street" of substantial scale had taken shape on Huimin Road in Xinhui. After the outbreak of the War of Resistance against Japanese Aggression, war raged on for years; the "brush-making street" of Xinhui was occupied by the Japanese troops, and the brush-making industry declined. Craftsmen of Maolong brush-making scattered and moved to Hong Kong. Later, there remained only a few Maolong brush shops in Hong Kong.

Plum Blossom by Guan Shanyue, using Maolong brush

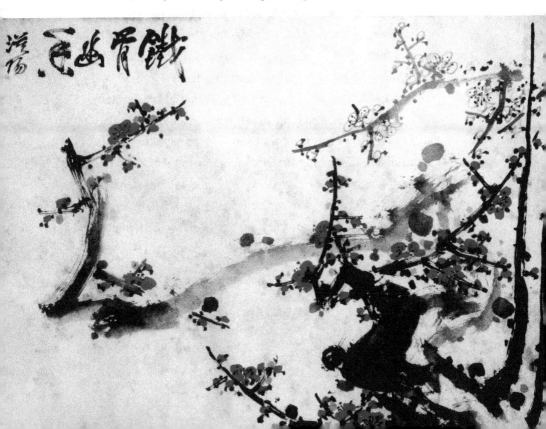

After the re-establishment of normal diplomatic relations between China and Japan in 1978, a Japanese delegation visited China. Some representatives talked about past stories on having entrusted someone to buy Maolong brushes prior to the founding of the People's Republic of China, and they proposed to buy a batch of Maolong brushes and bring them back to Japan. By then, Maolong brush, a gem of Lingnan folk art, has been back on the radar screen.

In February 2011, Chinese Culture and Art Association and Tokyo Painting Academy jointly organized the "China-Japan Calligraphy and Painting Masterpiece Exhibition and China-Japan Friendship Calligraphy and Painting Exchange Seminar" in Tokyo. Long Junqiu, a calligrapher from Jiangmen City, had two pieces of work penned with Maolong brushes in running script admitted to China-Japan Calligraphy and Painting Masterpiece Exhibition, titled "Viewing the Wide Sea" and "Chairman Mao's Poem" respectively. While his calligraphy work written with Maolong brush was collected by Tokyo Painting Academy of Japan; the work is a poem composed by Chen Baisha, describing the Jiangmen customs of the Ming Dynasty, "Spring waves leveled the two banks of Jiangmen, half intoxicated I rode a boat in the sky. Seat grew cold and candle snuff flickered, I asked for the time of the night, the Lianpeng Ford was about to sound about midnight."

Appreciating a tremendous Chinese painting drawn by the brush

In June 2008, "Baisha Maolong Brush-Making Technique" was placed in the Catalog of National Intangible Cultural Heritage for its historical, artistic, aesthetic and environmental-friendly values.

Inheritor

Protecting Tradition and Innovating

Zhang Ruiheng, the inheritor of Baisha Maolong brush-making technique, has been engaged in developing and making Maolong brushes for nearly 20 years. He has set up a handcraft workshop to make Maolong brush, and created calligraphy and painting with Maolong brush to promote the brush. Baisha Maolong brushes made by Zhang won Excellence Award of the First Folk Crafts Exhibition of Guangdong Province, and were collected by the Guangdong Provincial Museum and the French Reunion National Book Exhibition. Famous Lingnan calligraphers and painters, including Gao Jianfu and Guan Shanyue, together with prominent painter Liu Haisu and Wu Zuoren, have also painted with Maolong brushes.

Born in a family that once ran the business of antique furniture, Zhang found Chen Baisha's calligraphy on the wooden boards in old furniture when he was a child. He also found several worn Maolong brushes, which aroused his interest in Maolong brushes. In 1978, after the re-establishment of diplomatic relations between China and Japan, a Japanese delegation visited China on cultural exchanges and requested to purchase Maolong brushes. Xinhui Industrial Art Factory set up a trial manufacture group to develop Maolong brush. The then 17-year-old Zhang Ruiheng passed the screening exam with his solid drawing skills and became a worker in making Maolong brush.

Using Maolong brush to paint

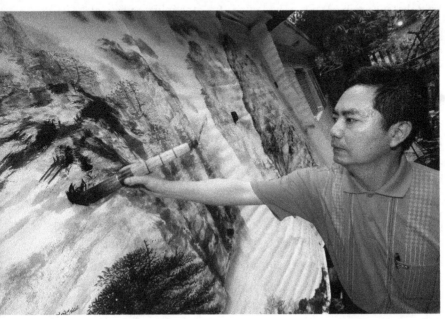

Due to the scarcity of users for Maolong brush and hence little profit made therefrom, the factory was merged into a garment factory four years later. In order to prevent the loss of Maolong brush-making skills, Zhang Ruiheng invited brush-makers to his home to do the making, and conducted active innovation on Maolong brush. In the 1980s, Zhang Ruiheng created his unique "Maolong Row-Brush" for the creative work of Chinese paintings, and formed his own style of using the Maolong brush, such as diluting the ink for lighter shades or texture. Some calligraphers and painters think that painting with Maolong brush can better highlight the painter's strength, and more and more people begin to use Maolong brush for painting. In the early 1990s, Zhang Ruiheng was transferred to Xinhui Gangzhou Painting Academy to take charge of the academy. He then established a handicraft workshop called "Maolong Xuan", engaged in promoting Maolong brush in half-sale and half-present manner.

In 2007, Zhang Ruiheng came into a notice in newspaper which said that a certain Mr. Deng had applied for the initial review of "Maolong" trademark to the State Administration for Industry and Commerce. In order to prevent the unique cultural heritage of Jiangmen from becoming a means for profit to others, he prepared materials and entrusted an agency to handle it at his own expense. The opposition application successfully terminated Deng's trademark application and prevented Xinhui's unique cultural heritage from being registered unjustifiably.

Presently Maolong Xuan Brush-Making Culture Museum has been set up in Gangzhou Painting Academy. Visitors can learn about the history of Maolong brush, and participate in the making of Maolong brush. Pertinent departments assisted in the completion of the Maolong Thatched Cottage in Xinhui Shijian Park in 2014, which brings forth more carriers for displaying

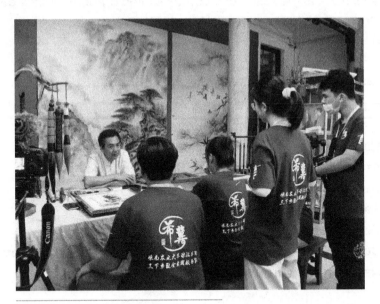

Zhang lectures the technique of brush making

Maolong culture. In addition to planting cocongrass, there are also scheduled activities such as Maolong brush-making craftsmanship and Maolong brush calligraphy on exhibit, allowing visitors to get a firm grip on the charm of Maolong brushes.

Nowadays, Zhang Ruiheng tries to support some small pen-making workshops and encourages them to produce high-quality Maolong brushes. He also encourages them to inherit retro craftsmanship and use more precious materials, such as red sandalwood and rosewood for pen holders, jade or stone sculpture for brush sleeve in an effort to bring Maolong brush upscale. "I hope that through market transaction activities and our academy's acceptance into the provincial base for intangible cultural heritage inheritance, the inheritance and development of Maolong culture will win more support," Zhang said.

This book is the result of a co-publication agreement between Nanfang Daily Press (CHINA) and Paths International Ltd. (UK)

--

Title: Maolong Brush: A Unique Instrument for Calligraphy
Author: Elegant Guangdong Series Editorial Board
Hardback ISBN: 978-1-84464-721-7
Paperback ISBN: 978-1-84464-722-4
Ebook ISBN: 978-1-84464-723-1
Copyright © 2022 by Paths International Ltd., UK and by Nanfang Daily Press, China

Paths International Ltd
www.pathsinternational.com

Published in United Kingdom